T0096596

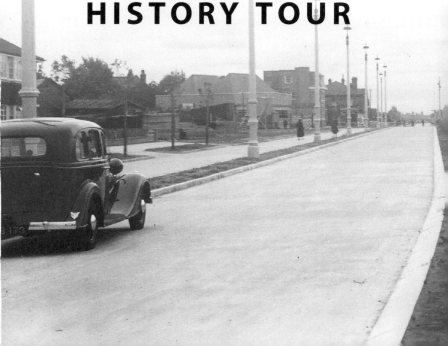

SPEKE
HISTORY TOUR

First published 2020

Amberley Publishing
The Hill, Stroud,
Gloucestershire, GL5 4EP
www.amberley-books.com

Copyright © David Paul, 2020
Map contains Ordnance Survey data
© Crown copyright and database
right [2020]

The right of David Paul to be
identified as the Author of this work
has been asserted in accordance with
the Copyrights, Designs and Patents
Act 1988.

ISBN 978 1 3981 0205 7 (print)
ISBN 978 1 3981 0206 4 (ebook)

All rights reserved. No part of this
book may be reprinted or reproduced
or utilised in any form or by any
electronic, mechanical or other means,
now known or hereafter invented,
including photocopying and recording,
or in any information storage or
retrieval system, without the permission
in writing from the Publishers.

British Library Cataloguing in
Publication Data.
A catalogue record for this book is
available from the British Library.

Origination by Amberley Publishing.
Printed in Great Britain.

ACKNOWLEDGEMENTS

I would wish to place on record my thanks to the many people who helped me gather information and photographs of Speke, especially Stella Davenport for sharing her wealth of knowledge of Speke and to John Blake, who gave me access to and permission to use so many of the photographs from his personal collection.

Much of the text of *Speke History Tour* is based on my previous research about Speke.

Finally, while I have made every effort to ensure that the notes in this book are factually correct, any errors or inaccuracies are mine alone.

INTRODUCTION

As far back as 1066 Speke was an integral part of Uctred's manors, together with West Derby and Huyton, and, even as recent as the turn of the twentieth century, the population of the village was a mere 400 souls.

At the beginning of the twentieth century, the nearby city of Liverpool embarked upon a massive programme of slum clearance, which entailed a large-scale programme of rehousing for a significant number of the city's population. In the immediate post-war years, the population of Speke had grown to somewhat in excess of 25,000.

The initial planning concepts for Speke closely followed the popular garden city movement, which sometime earlier had created Stevenage and Welwyn Garden City. Speke was set to become an independent town; the plans included provision for places of worship, schools, a sports centre, shops, swimming pool, laundries and a golf course.

In 1921 the last owner of Speke Hall and the Speke estate, Miss Adele Watt, died. Then, in 1928 Liverpool Corporation, seeing a solution to its housing problems, bought the land for the Speke estate from the trust managing Miss Watt's estate. Some years later, in 1932, the estate was incorporated into the city of Liverpool, having formerly been part of Whiston rural district. In 1937 work started on the development of the Speke estate. Much social engineering was injected into the project at the planning stage, with emphasis being placed upon building houses for a range of different professions

and incomes. The architect of the Speke estate, Lancelot Keay, endeavoured to meet this objective, having a wide variety of different house styles built on the estate. Keay also envisaged building all of the necessary amenities to complete the 'living experience', but this latter concept never reached fruition.

Little emphasis was given initially to social amenities, but, by the 1960s there was some evidence that the social needs of the people living on the estate were being taken into account, and new shopping precincts were developed. A number of churches were opened, as were a number of public houses. Other developments included new schools, a public swimming baths, a police station, a fire station, a small park, an ambulance station, medical surgeries and a new library. But, even so, the area fell into decline during the 1970s and '80s, with increasing levels of unemployment. In 1981 the Speke Enterprise Zone was set up by the Thatcher government, but this spectacularly failed to attract any new factories to the region. In the 1990s European Union money helped to develop and secure the Speke-Garston Development Corporation, which aided the area's economic recovery.

The partial economic recovery of Speke is indicative of the region as a whole, but progress is being made, and there is tangible evidence in many of the enterprise industries that are developing along the airport perimeter roads.

A tour around Speke provides evidence of its long history, but there is an ongoing history that is still developing.

David Paul
27 October 2019

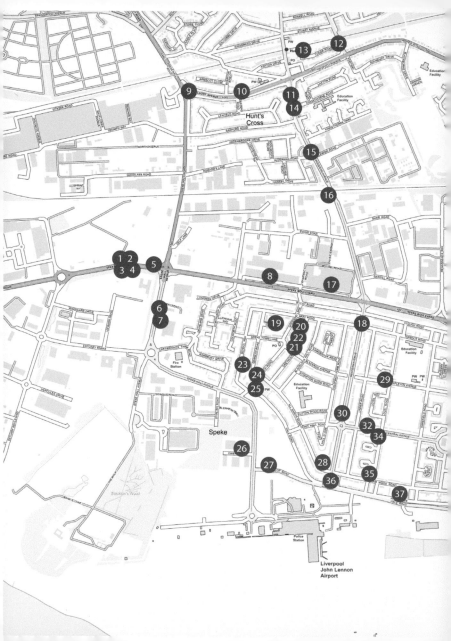

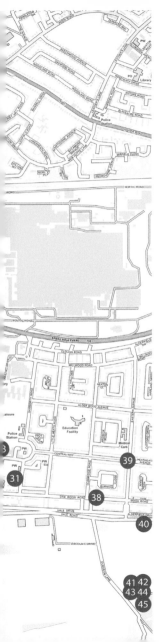

Key

1. Travelling from Garston to Speke
2. Bryant & May
3. Speke Road Gardens
4. Airport Terminal Building
5. Speke Road
6. Speke Hall Lodge
7. Speke Hall
8. Brown, Bibby & Gregory
9. Junction of Higher Road and Speke Hall Road
10. Hillfoot Avenue
11. Hunts Cross crossroads
12. Macket's Lane shops
13. Hunts Cross railway station
14. Woodend Avenue at Hunts Cross
15. Woodend Avenue
16. The Old Parsonage
17. Evans Medical
18. The junction of Western Avenue and Tarbock Road
19. Speke Town Lane
20. Work starting on the new estate of Speke in 1938
21. Church Road
22. The Crescent shopping arcade
23. All Saints church hall
24. All Saints Church
25. Hale Road
26. Dunlop's
27. Dunlop Road
28. Shops in Western Avenue
29. Stapleton Avenue
30. Western Avenue
31. Ganworth Road
32. Central Avenue
33. Central Parade
34. Speke County Comprehensive School, Central Avenue
35. Dam Wood Road
36. Hale Road Improvement Scheme
37. Hale Road leading to Eastern Avenue and Hale
38. Hale Road towards Eastern Avenue
39. Eastern Avenue
40. The road from Speke to Hale
41. Hale War Memorial
42. Church End, Hale
43. The Manor House, Hale
44. The Childe of Hale
45. Hale Head lighthouse

1. TRAVELLING FROM GARSTON TO SPEKE

More or less as soon as this road was completed, work started on building a dual carriageway from Garston towards the soon-to-be-built Speke estate, as can be seen in the more recent image.

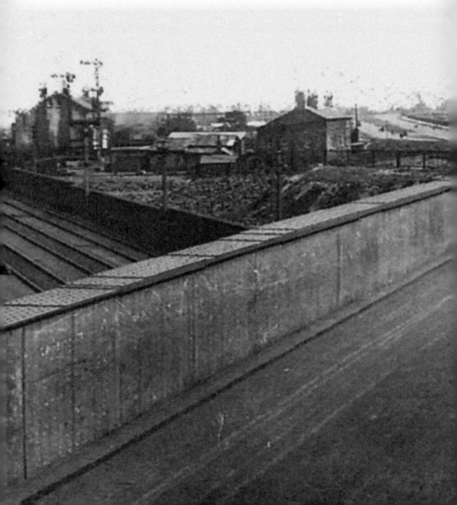

2. BRYANT & MAY

The match making company of Bryant & May originated in Bow, London, in the mid-nineteenth century. From that time onwards the company acquired a number of other competing match manufacturing companies. The British Match Corporation was formed in 1927 when Bryant & May merged with the British subsidiary of the Swedish Match Company. After many years of expansion, there was a marked turndown in the market beginning in the early 1970s. This, inevitably, resulted in factory closures, and the Bow factory closed in 1971. The Garston factory closed in 1994 and the company transferred its match production facility to factories in Sweden.

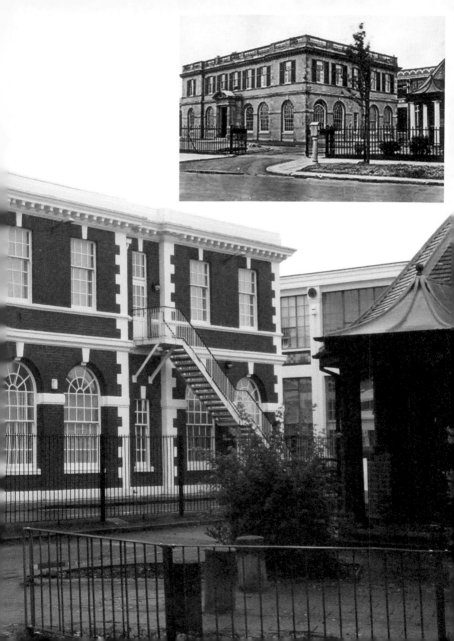

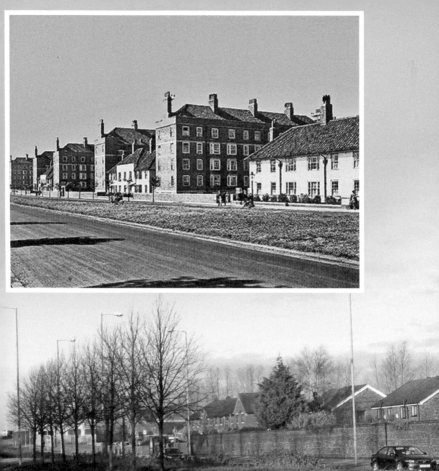
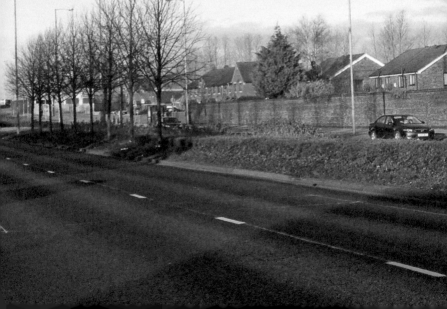

3. SPEKE ROAD GARDENS

The tenements, officially known as Speke Road Gardens – colloquially called 'the tennies' – were started in 1932 and completed by 1933. Sometime earlier the site was occupied by Cowen's nursery and before that by a vineyard that was owned by Mr Meredith. The grapes were highly sought after and were enjoyed by, among others, Queen Victoria and the Pope. But that was a long time ago. When Queen Elizabeth came to Liverpool in the 1950s the council repainted 'the tennies', but only on one side – the side that the queen could see from her car! All the hedges along her route were also trimmed, but again, only on the one side. The tenements have long gone, and new houses have been built.

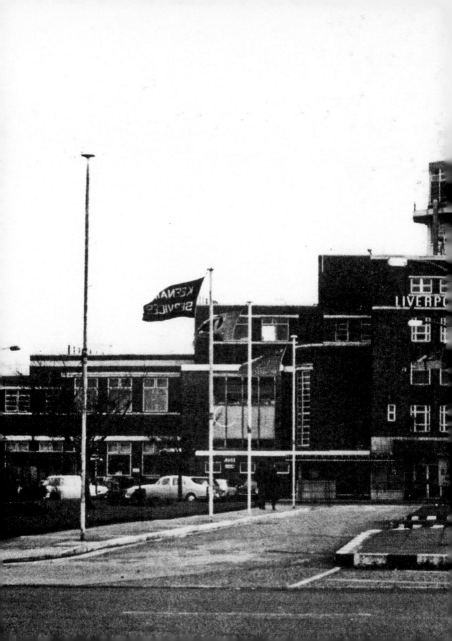

4. LIVERPOOL AIRPORT

When the first airport was opened in Liverpool on 1 July 1933, it quickly assumed the unofficial title of Speke Airport, although civic pride never acknowledged this. At the end of the Second World War the city council assumed control of the airport, and one of its first significant developments was to build a new runway and terminal building. The airport's official title is Liverpool John Lennon Airport.

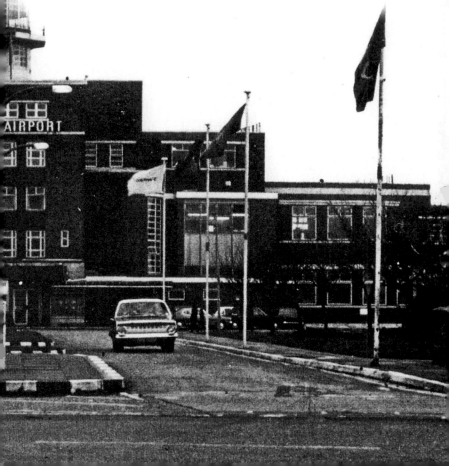

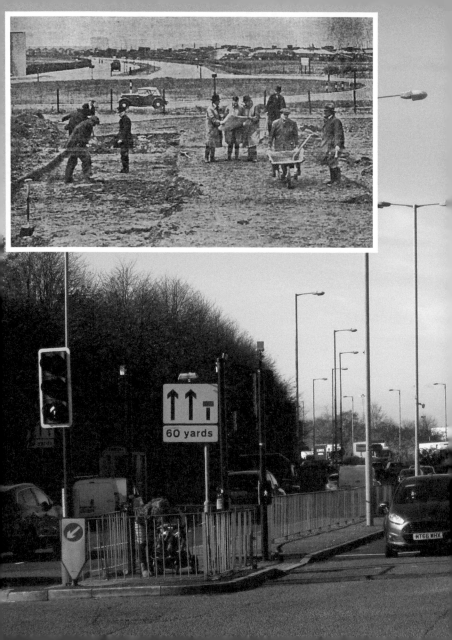

5. SPEKE ROAD

For many years the road was a single carriageway, but with increasing traffic flow to and from the city centre, the road was soon modified to a dual-lane carriageway. More recently a retail park has been built between Speke and Garston, so the road is now even busier.

6. SPEKE HALL LODGE

The North Lodge was built *c*. 1868 after quotes, ranging from £348 to £404, had been received from four different builders in and around the area. The other lodge built was known as West Lodge. North Lodge is a Grade II listed building.

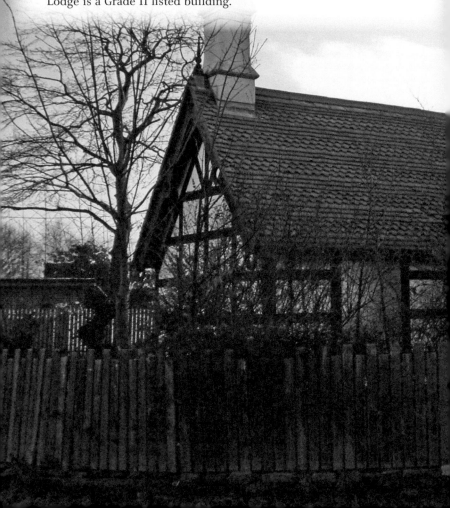

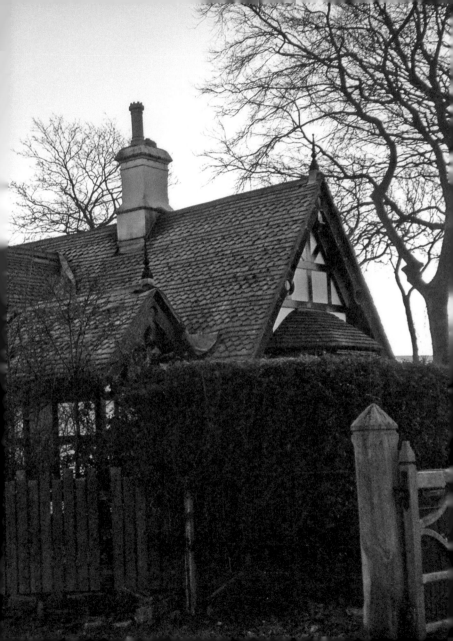

7. SPEKE HALL

Although it is known that earlier buildings had been built on this site, the current hall was first built under the direction of Sir William Norris in 1530. At that time Sir William had the Great Hall built, and the following year, 1531, he had built the Great Parlour and the North Bay. Later work included the building of the South Wing and the West Wing. There has been no significant building work on the hall since 1598 when Edward Norris added the North Range. The Norris family owned the hall until 1736 when the heiress, Mary Norris, married Sir Sidney Beauclerk. Then, in 1795, a Liverpool merchant, Richard Watt, bought the hall and the estate from the Beauclerks. Miss Adelaide Watt inherited the hall when she was just twenty-one years of age. Speke Hall is a Grade I listed building.

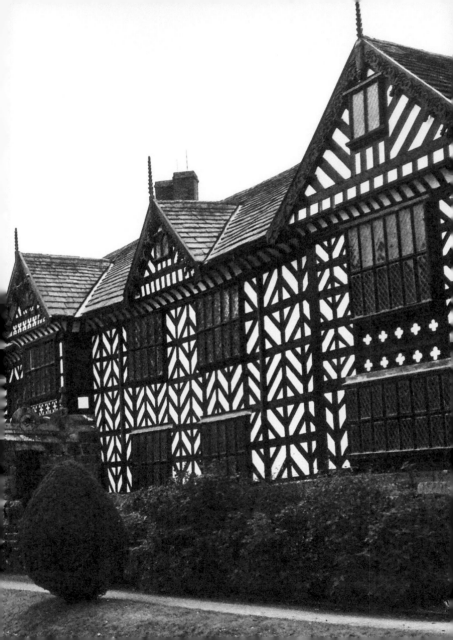

8. BROWN, BIBBY AND GREGORY

Shortly before the start of the Second World War the Speke factory of Brown, Bibby and Gregory was built and opened in 1938. The factory manufactured and printed labels, cartons, wrappers and bags for distribution throughout the world. The company was later sold to The Metal Box Company. The factory has now been demolished and is currently being converted, in part, to a retail park.

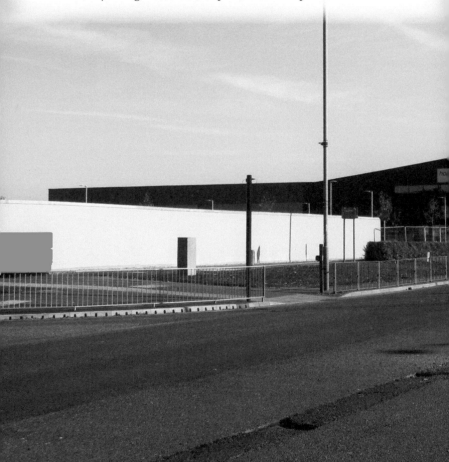

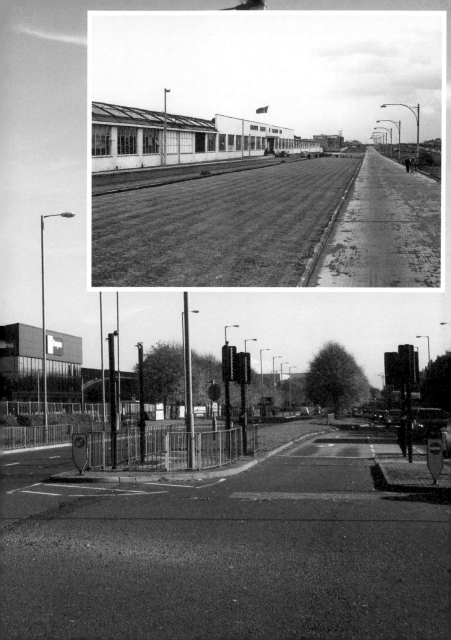

9. JUNCTION OF HIGHER ROAD AND SPEKE HALL ROAD

During the immediate post-war years, the density of traffic along Higher Road and Speke Hall Road soon meant that a massive roundabout needed to be built to assist the flow of traffic. However, the traffic increased to such an extent that an elaborate system of integrated traffic lights had to be installed. Even with this advanced technology, there is still some congestion at the approach to the more recently built retail park.

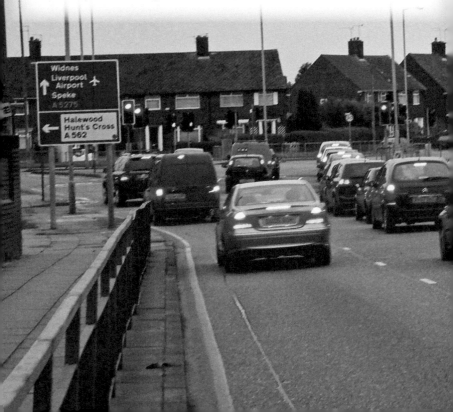

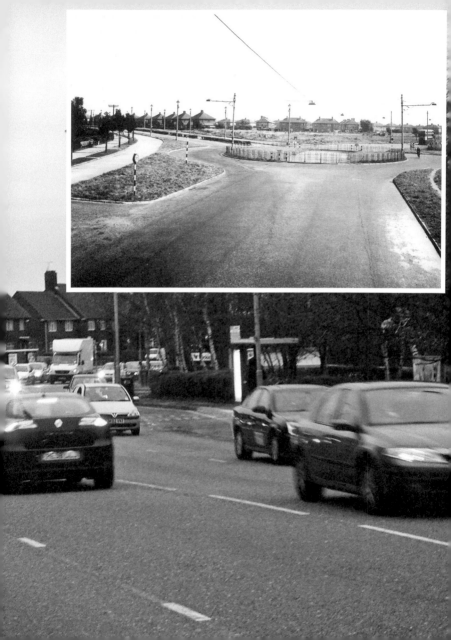

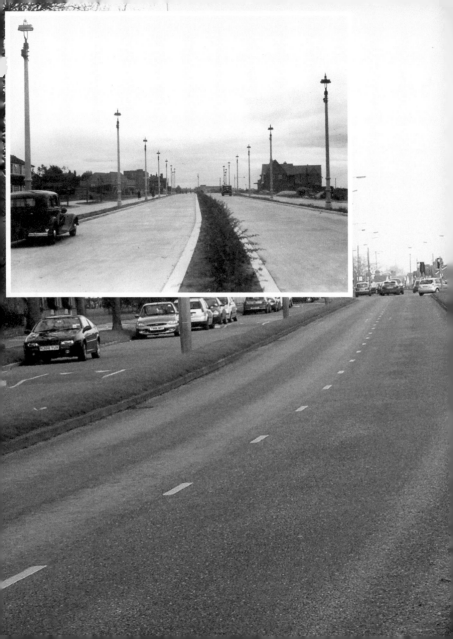

10. HILLFOOT AVENUE

The sweep on Hillfoot Avenue is still the same today as when the road was constructed, but the traffic is very different.

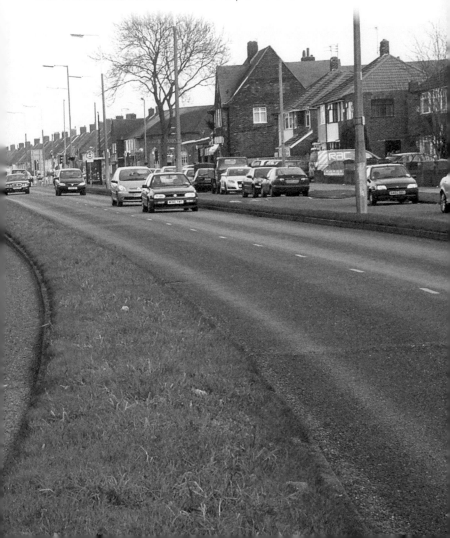

11. HUNTS CROSS CROSSROADS

The Hunts Cross Hotel was a hostelry that many people called at when stopping at the village of Hunts Cross just a few miles along the lane from the village of Speke. The original hotel is no longer there, but a new hotel has been built just behind the shopping arcade and it is every bit as popular.

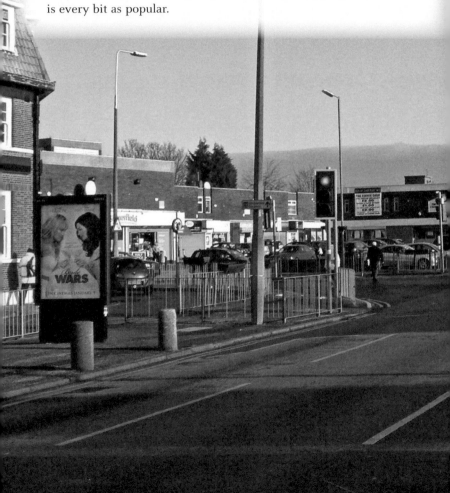

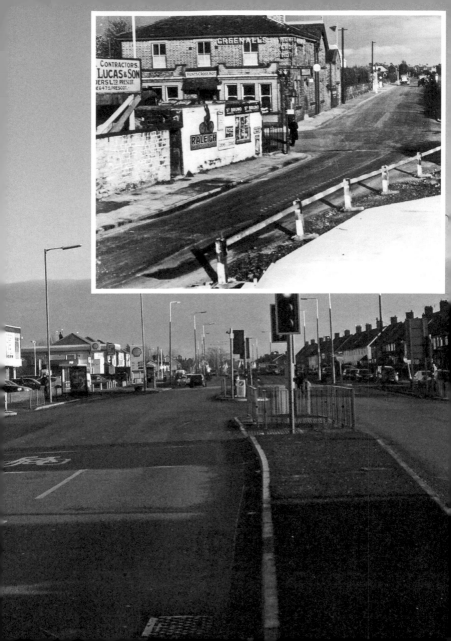

12. MACKET'S LANE SHOPS

As the village of Hunts Cross developed, it soon became obvious that there was a need for some new shops to be built. The shops at the top of Macket's Lane are still there, but there is a very different way of retailing these days.

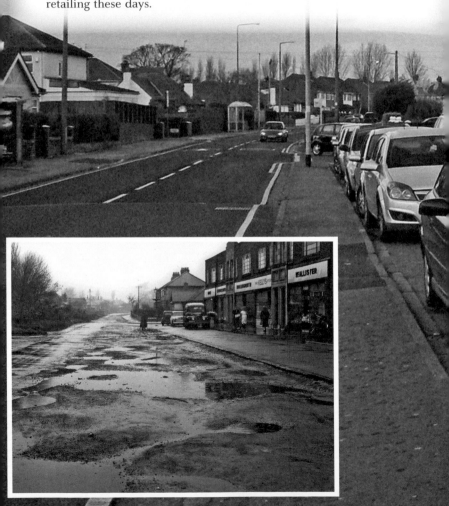

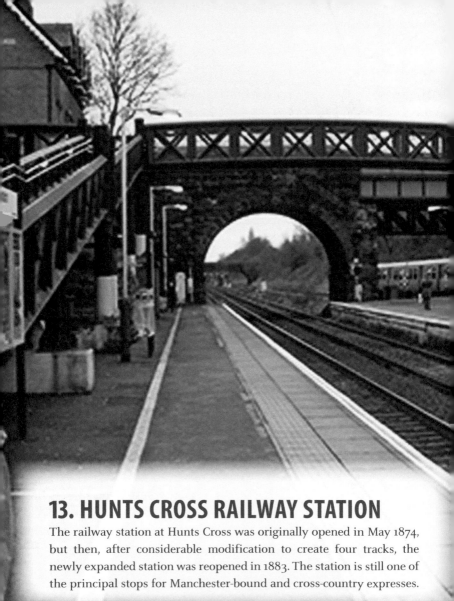

13. HUNTS CROSS RAILWAY STATION

The railway station at Hunts Cross was originally opened in May 1874, but then, after considerable modification to create four tracks, the newly expanded station was reopened in 1883. The station is still one of the principal stops for Manchester-bound and cross-country expresses.

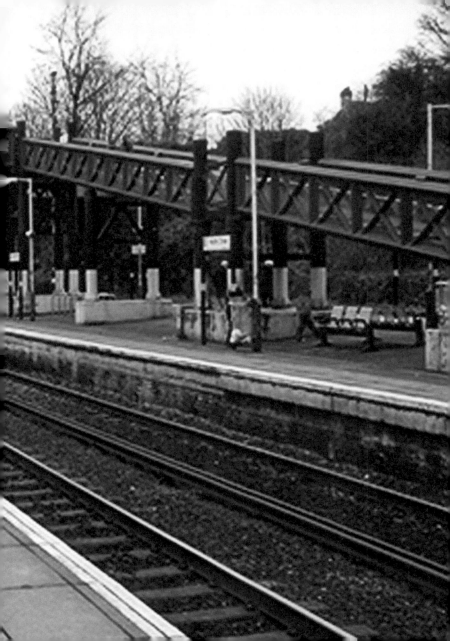

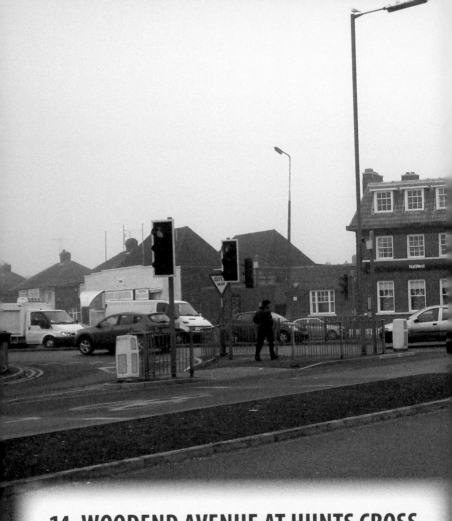

14. WOODEND AVENUE AT HUNTS CROSS

The old Hunts Cross Hotel can be seen on the right with the sandstone cross, railed off, near to the bystander on the left. A stray dog wouldn't stand much chance crossing the road in today's heavy traffic!

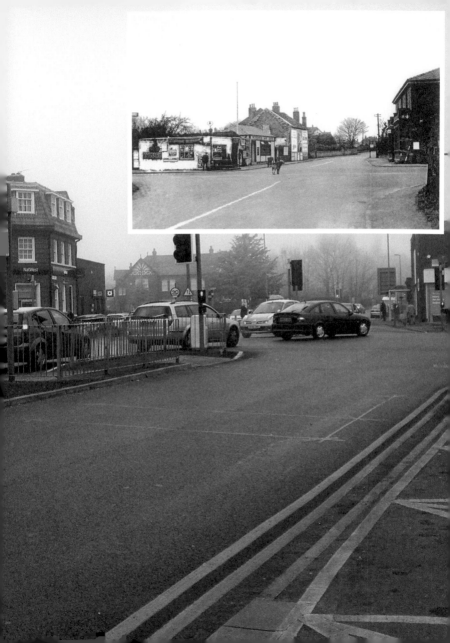

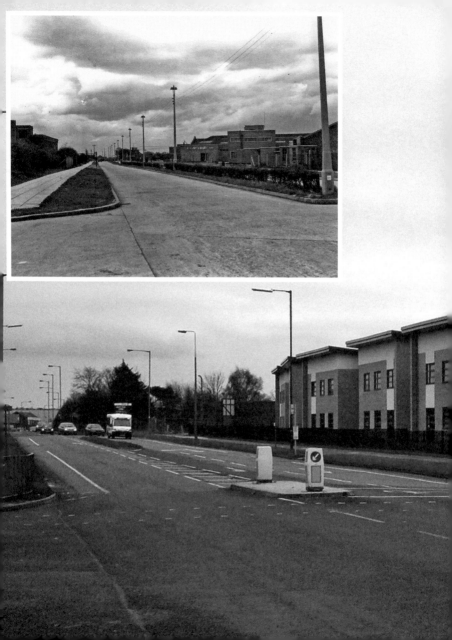

15. WOODEND AVENUE

After Woodend Lane became dual carriageway, its name also changed to Woodend Avenue. Many manufacturing concerns had premises along the road, there being a ready supply of labour from the surrounding area. Industries thrived until the mid-1990s, when there was a reduction in the manufacturing base. Since that time, much of the new build has been apartments and small office blocks.

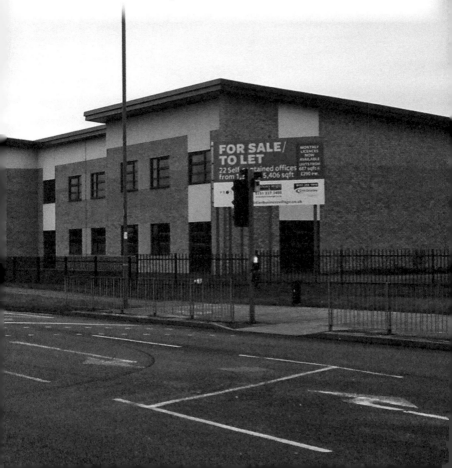

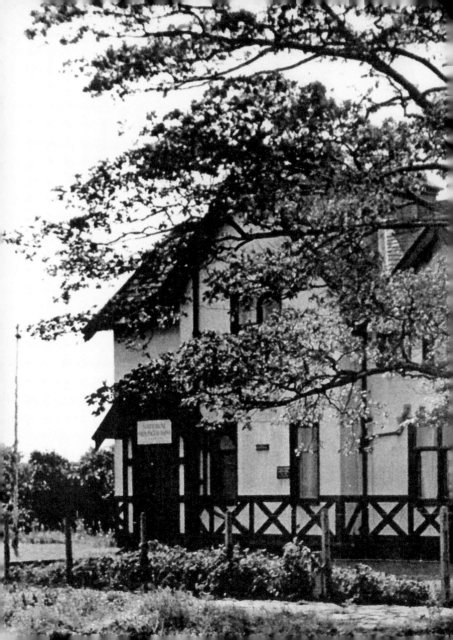

16. THE OLD PARSONAGE

The old parsonage in Woodend Lane afforded direct access to All Saints Church for the vicar of Speke, and the nearby Speke station meant that the vicar and his family could enjoy rail travel whenever it was necessary. The parsonage was demolished many years ago.

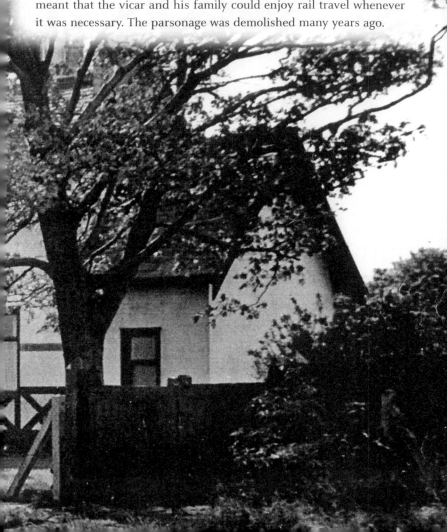

17. EVANS MEDICAL SUPPLIES

Many companies were based at Speke directly after the Second World War, not least of which was Evans Medical Supplies at the top of Speke Boulevard. Many of the staff employed at the site were drawn from the local workforce, and Corporation buses brought other workers in from all over the city.

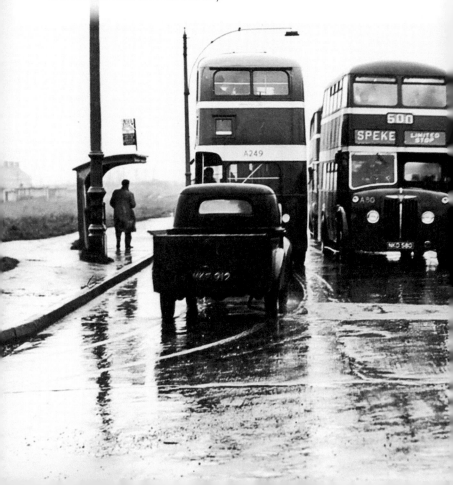

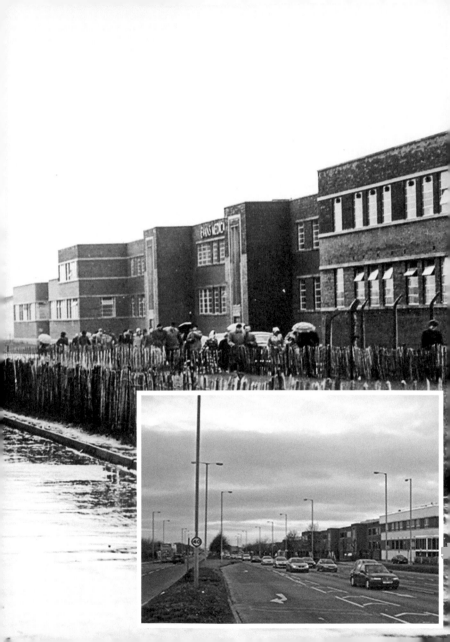

18. THE JUNCTION OF WESTERN AVENUE AND TARBOCK ROAD

Many ideas were floated when Speke was first conceived, and social engineering was a particularly high priority at that time, as can be seen from this image showing the junction of Western Avenue and Tarbock Road. Different types of dwelling houses are still very much in evidence, but the social planning aspect appears to have slipped down the list of identified priorities.

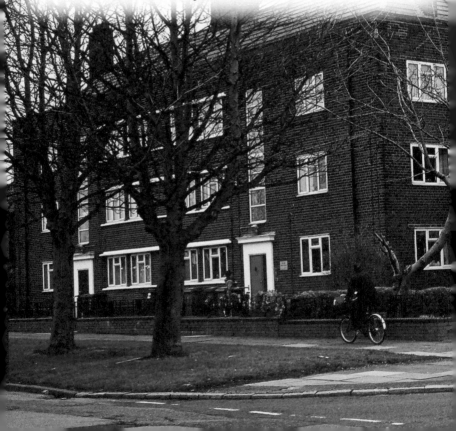

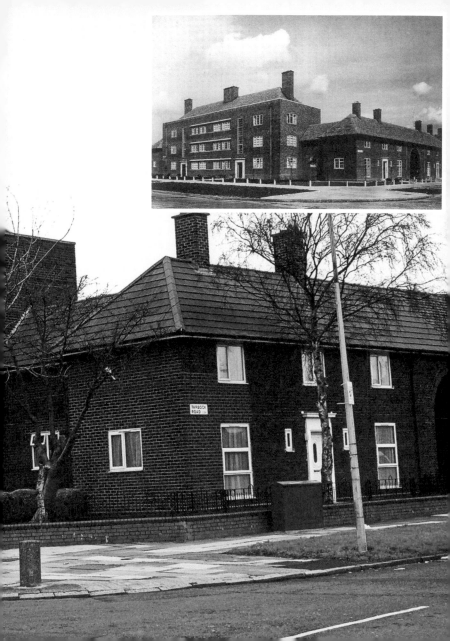

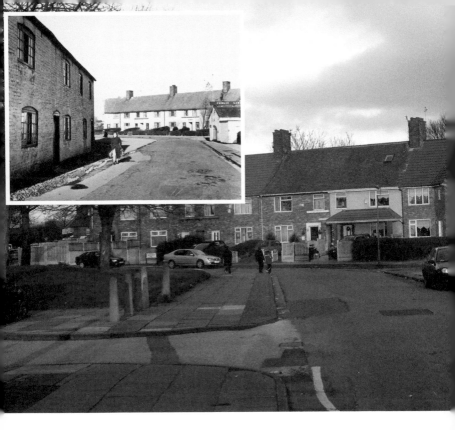

19. SPEKE TOWN LANE

Some of the cottages in Speke Town Lane were still standing, well after many of the new houses had been built. Speke's temporary library had now been moved from one of the houses in All Saints Road to the old smithy, and the estate was beginning to become more established. When the cottages were eventually demolished, a new shopping centre, the Crescent, was built on the site.

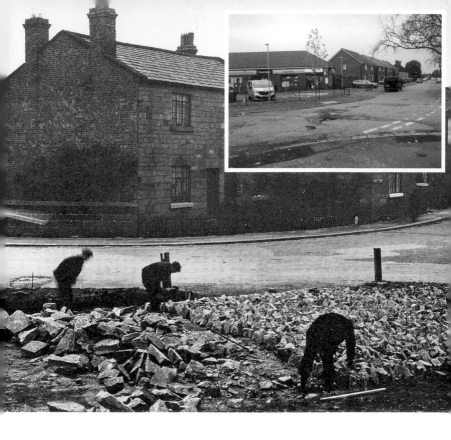

20. WORK STARTING ON THE NEW ESTATE OF SPEKE, 1938

Road construction was not mechanised in 1938 when this work was started near to where the Crescent shopping arcade was to be built. It's very different now, as the Crescent itself has now been demolished and replaced by two purpose-built retail outlets and a number of houses.

21. CHURCH ROAD

The houses in Church Road were some of the first new houses to be built in Speke; there is a marked contrast to the cottages that were still standing on the far side of the road. Some years later the Crescent shopping parade was built when the cottages were knocked down.

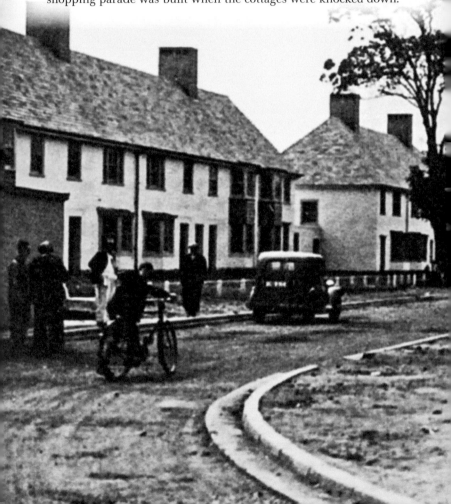

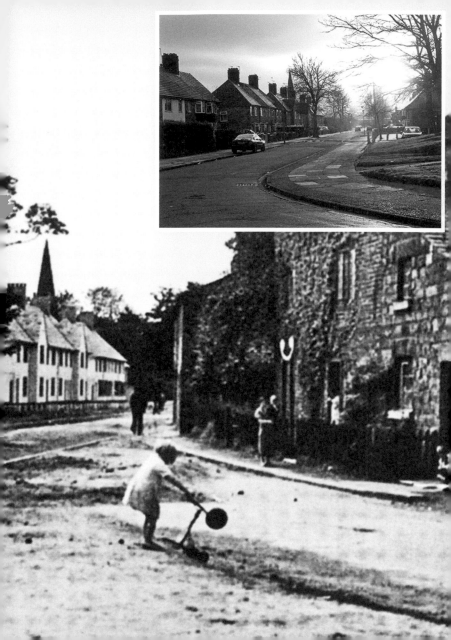

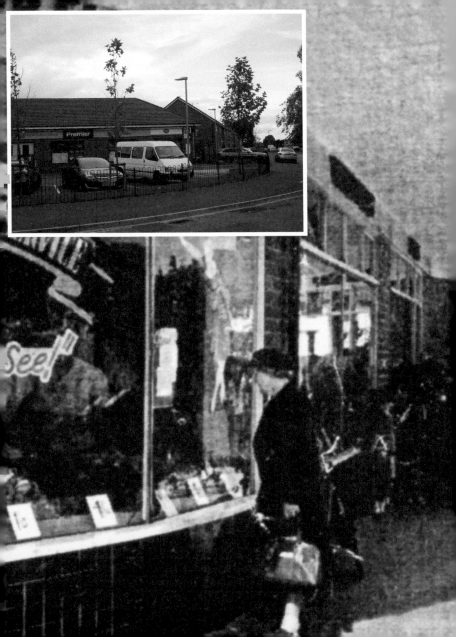

22. THE CRESCENT

Over the years changing patterns of shopping inevitably meant that fewer people were visiting the Crescent. So, following many years of disrepair and dilapidation, the arcade was finally demolished in 2017, making way for two purpose-built retail units and a number of two-bedroom homes and bungalows.

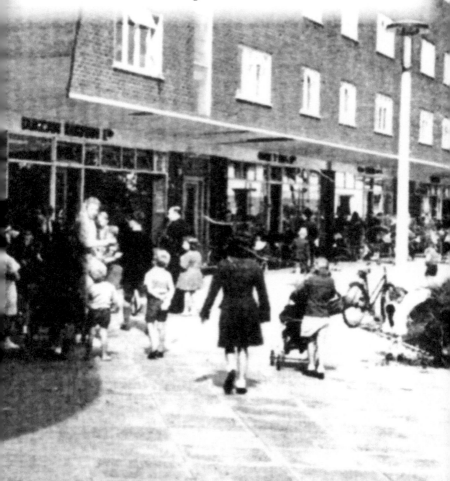

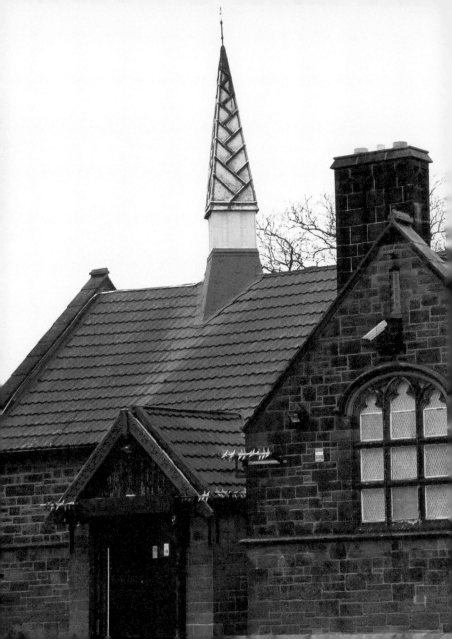

23. ALL SAINTS CHURCH HALL

All Saints church hall has stood on the same site since anyone can remember. Leonard Rossiter of *Rising Damp* fame started his acting career here, and, so the story goes, Paul McCartney was in the 16th Allerton Scout Group, which held their meetings in the church hall.

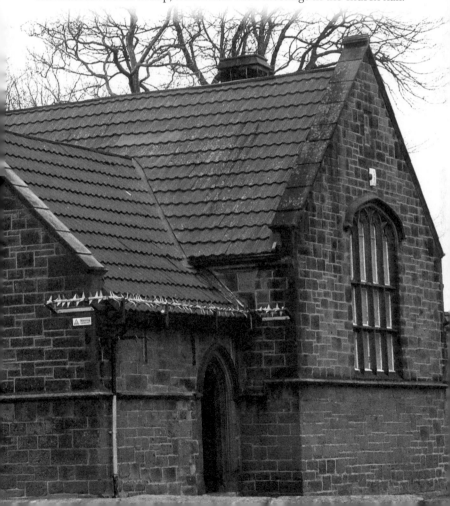

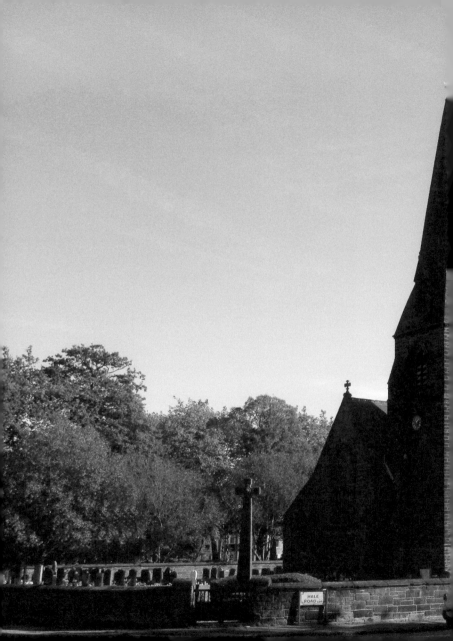

24. ALL SAINTS CHURCH

All Saints Church in Speke was built between 1872 and 1875 to mark the twenty-first birthday of Miss Adelaide Watt, the last owner of Speke Hall to live at the property. The church was designed by John Loughborough Pearson and consecrated by the Bishop of Chester on 21 June 1876. In the 1930s the church was enlarged so that a new vestry and office could be incorporated. Electric lighting was also installed at this time.

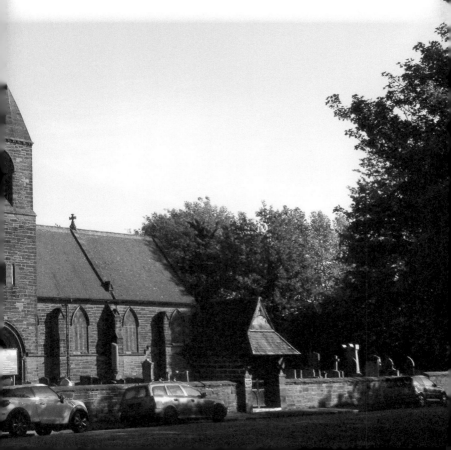

25. HALE ROAD

Hale Road was one of the first roads to be built in Speke after the end of the Second World War. Many of the houses were built with an attached garage – another 'first' for Speke. The original plans for the 'satellite town', which had been drawn up well before the war started, envisioned a bold experiment in social engineering, with a riverside promenade, a golf course, swimming baths and a cinema, among other social and cultural facilities, but austerity and economics changed that vision. Hale Road today is similar, in many respects, to what it was in the early 1950s.

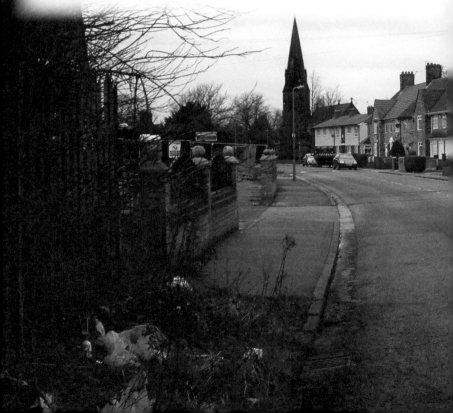

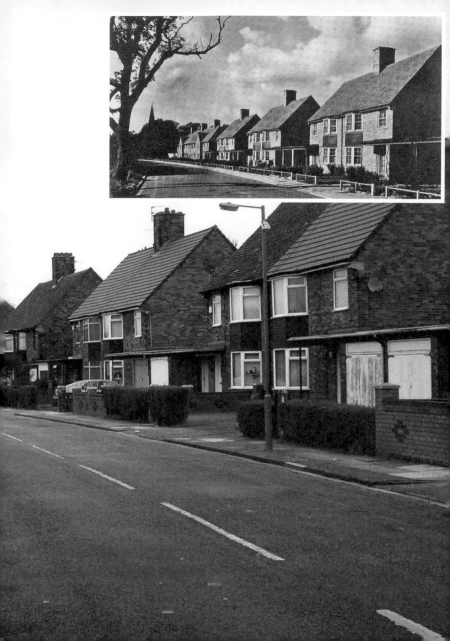

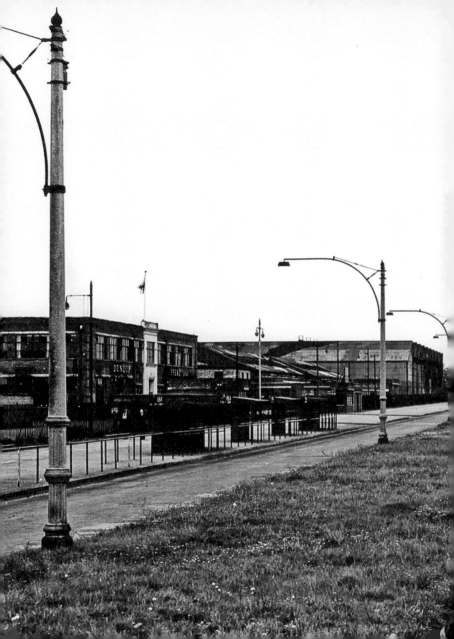

26. DUNLOP'S

Shortly after the end of the Second World War, the Rootes aircraft assembly plant at Speke was leased to the Dunlop Rubber Co. Ltd. Tyre and golf ball production continued at the Speke plant for a number of years, but Dunlop's market share in the sale of motorcar tyres declined, and the decision was taken to close the facility on 19 April 1979. The site now houses a number of 'Enterprise' development units, many having close links with the nearby John Lennon Airport.

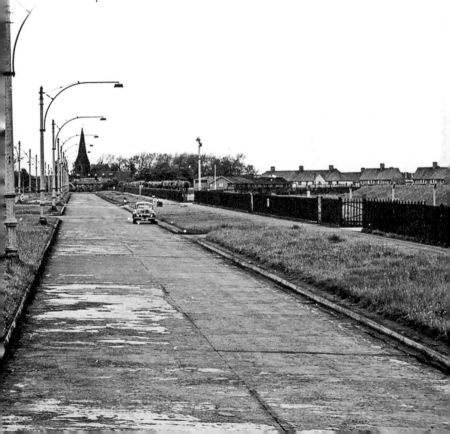

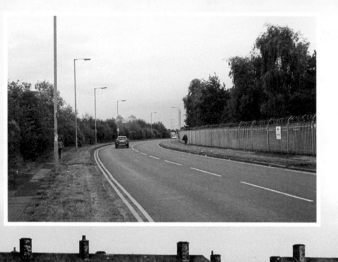

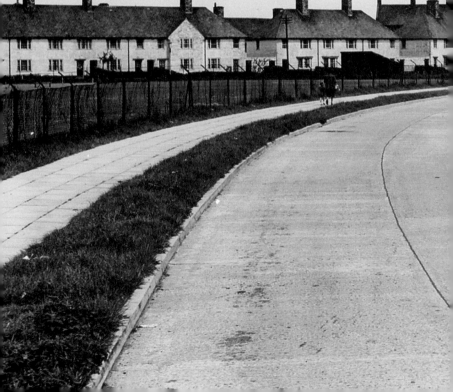

27. DUNLOP ROAD

Dunlop Road was a fairly obvious name for a road with one of the biggest tyre manufacturing factories in Europe at the end of it, but, Dunlop's is no longer there – nor is there any evidence that it ever was! The area where the factory once stood now services, in the main, the insatiable appetite and ever-increasing needs of the John Lennon Airport.

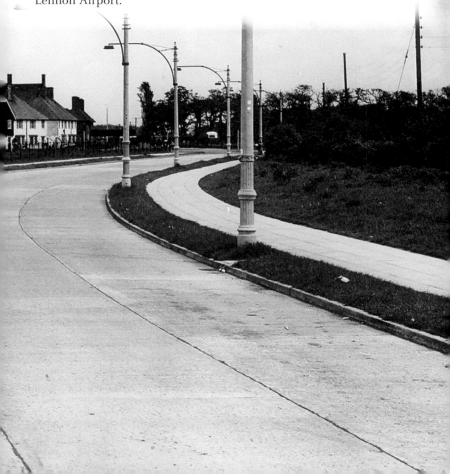

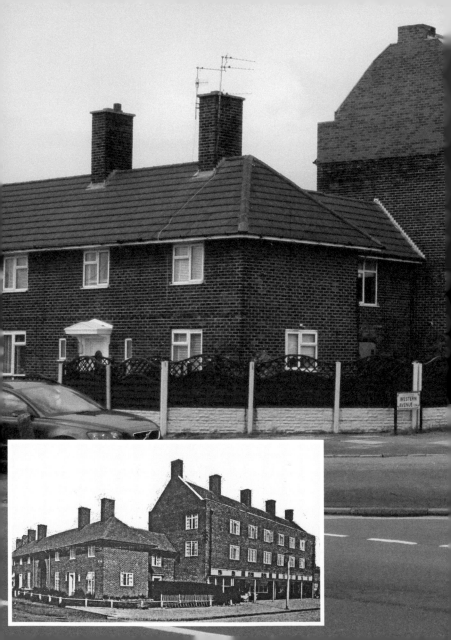

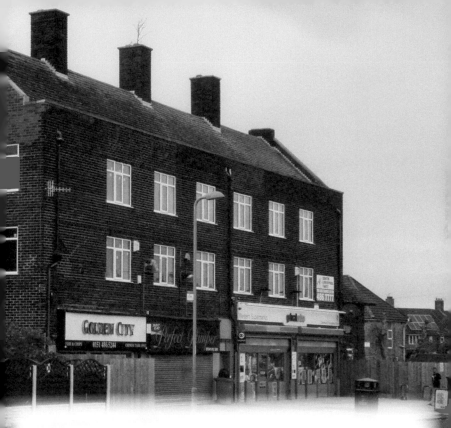

28. SHOPS IN WESTERN AVENUE

Shopping was something that wasn't forgotten when building the new estate, although many of Speke's residents would argue with this assertion. But, when building work was eventually started on a number of shopping centres, as they were to be known, it was envisaged that there would be a total of ninety shops, which meant that there would be four shops for each 1,000 residents. Many of the shops shown here at the bottom of Western Avenue have now closed, as shopping patterns have considerably changed in the twenty-first century.

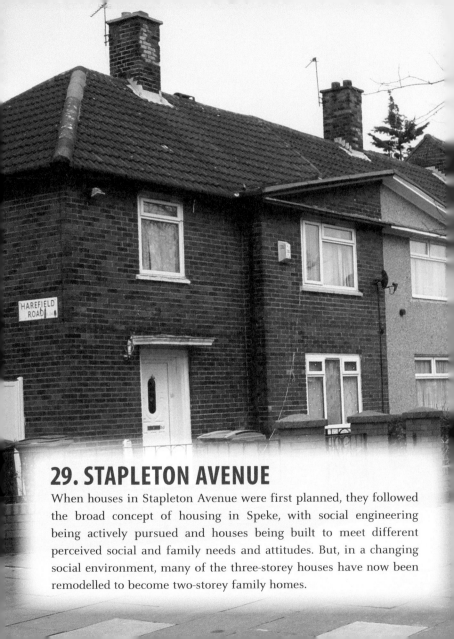

29. STAPLETON AVENUE

When houses in Stapleton Avenue were first planned, they followed the broad concept of housing in Speke, with social engineering being actively pursued and houses being built to meet different perceived social and family needs and attitudes. But, in a changing social environment, many of the three-storey houses have now been remodelled to become two-storey family homes.

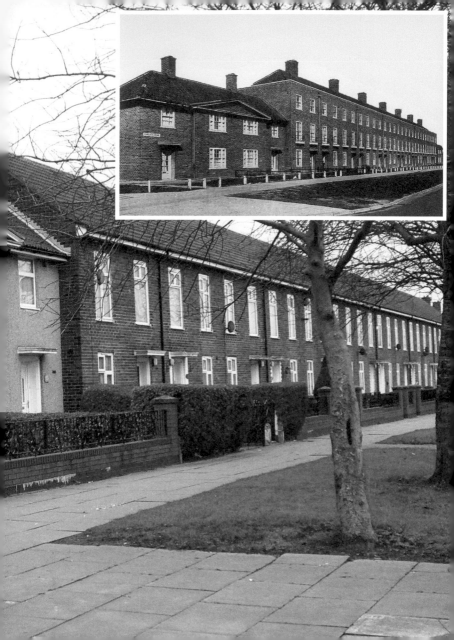

30. WESTERN AVENUE

The Pegasus public house was built at the bottom of Western Avenue after the houses had been completed, and, for many years, proved a popular meeting place. The pub has now been demolished to make way for new buildings and hotels necessitated by the insatiable appetite of John Lennon Airport.

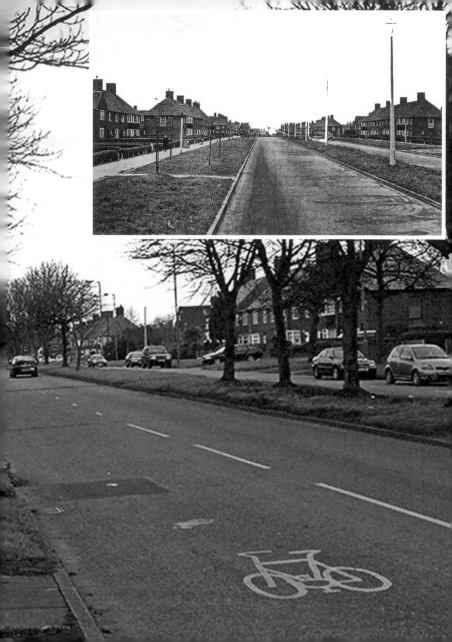

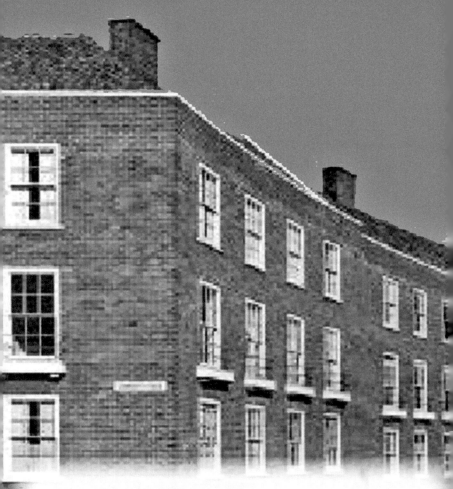

31. GANWORTH ROAD

Some of Speke's housing stock was of three storeys – a bold experiment in social engineering in the immediate post-war years of the early 1950s. However, attitudes, policies and needs change, so many of the houses have now been converted to more conventional two-storey properties.

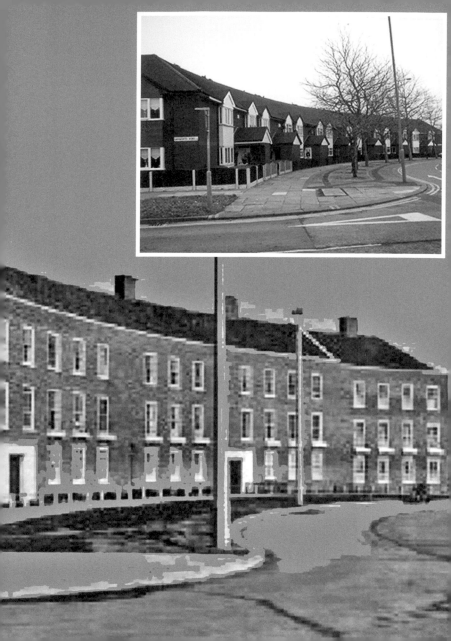

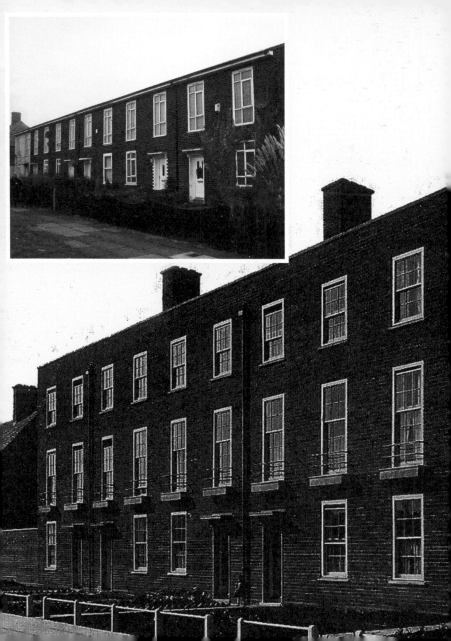

32. CENTRAL AVENUE

There were many large houses built in Speke similar to these houses in Central Avenue, the concept being an integral component in the social engineering approach being taken by the city council. But, since that time, plans and policies have been reassessed because of different prevailing social norms, and many of the three-storey houses have now been converted to two-storey dwellings.

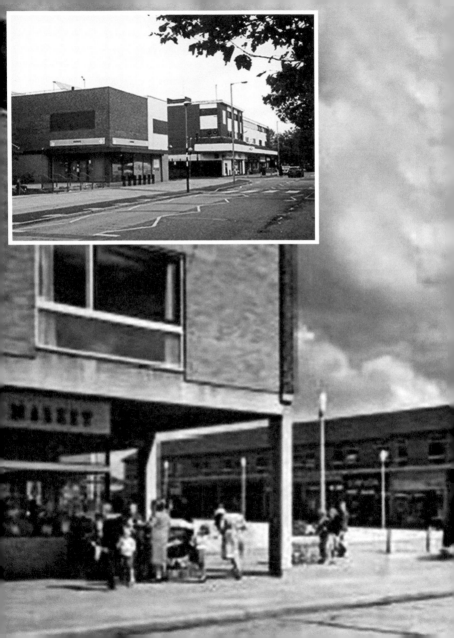

33. CENTRAL PARADE

Sometime towards the end of housebuilding in Speke, an ambitious programme of shop-building was started. Apart from shops in various strategic locations on the estate, the Central Parade, of almost sixty shops, was built as the main shopping arcade of the estate. The Parade served Speke until 2008 when, because of a completely new retail park in a different location, it was razed to the ground. A new complex has now been built, which incorporates a health centre, a pharmacy and a number of shops.

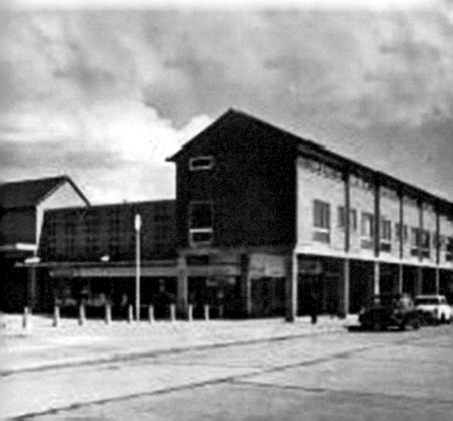

34. SPEKE COUNTY COMPREHENSIVE SCHOOL, CENTRAL AVENUE

As the Speke estate developed, a number of schools were built, and, when comprehensive education was introduced in the mid-1960s, Liverpool Education Authority was one of the first local authorities in the country to espouse the new concept. However, with demographic changes and changing educational priorities, the decision was made to demolish the school and utilise the land resource for more beneficial social purposes. The 'Mill Brow' development that was built on the Central Avenue site offers some three-bedroom shared-ownership homes and a number of two-bedroom rent-to-buy homes.

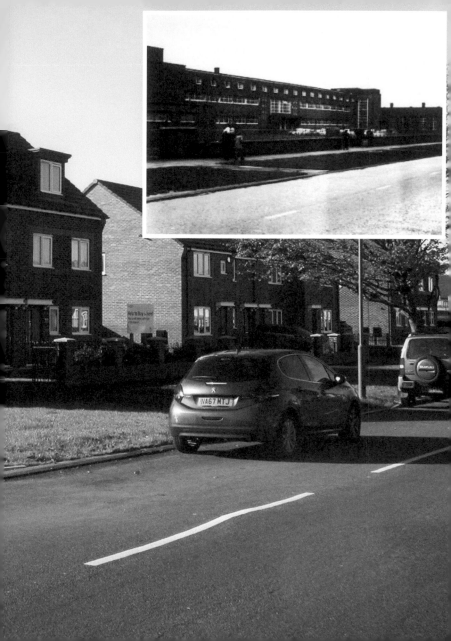

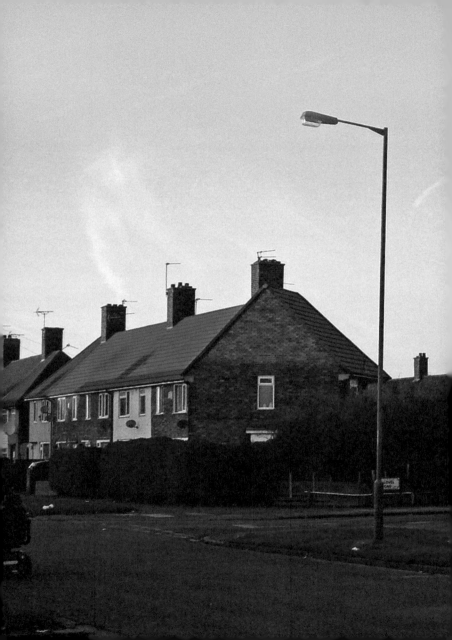

35. DAM WOOD ROAD

During the eighteenth and nineteenth centuries shipyards along the River Mersey built many ships for the Royal Navy, and much of the oak was obtained from one of the woods on the Speke estate, the Dam Woods. In the twentieth century a road close by to the original woods was constructed and named after the former woodland estate.

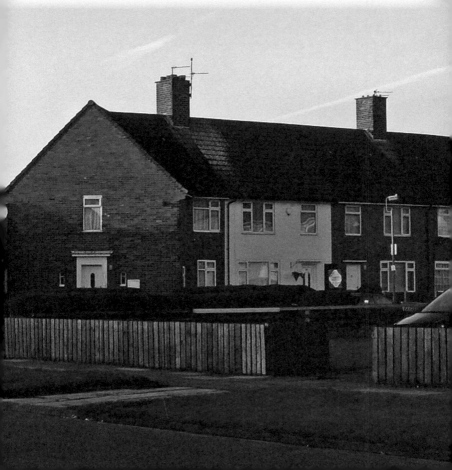

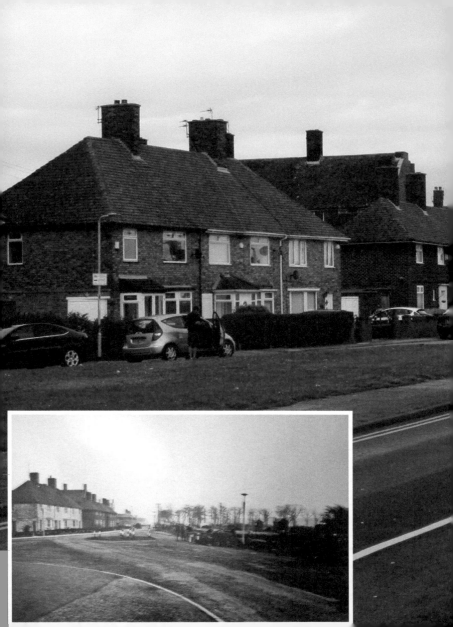

36. HALE ROAD IMPROVEMENT SCHEME

While infrastructure roads were being built on the estate itself – keeping pace with the ambitious housebuilding programme – the perimeter roads of Speke were not neglected, and the improvement scheme for Hale Road was completed in the immediate post-war years. In recent times, however, with increasing use being made of the nearby John Lennon Airport, the link road between Speke and Hale has assumed a more significant role.

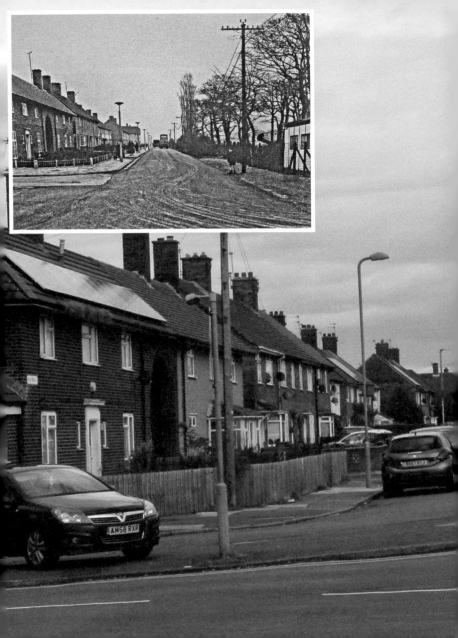

37. HALE ROAD LEADING TO EASTERN AVENUE AND HALE

Buses started to run along Hale Road as soon as the new Eastern Avenue was completed. This was the 'new' part of Speke. Houses on the far side of the Central Shopping Parade were known colloquially as 'new' Speke, although some of the residents in the original village had a different understanding of 'new'. The road now marks the current limit of the airport estate; however, like Topsy, the airport continues to expand in all directions, so who knows where it will be in another fifty years?

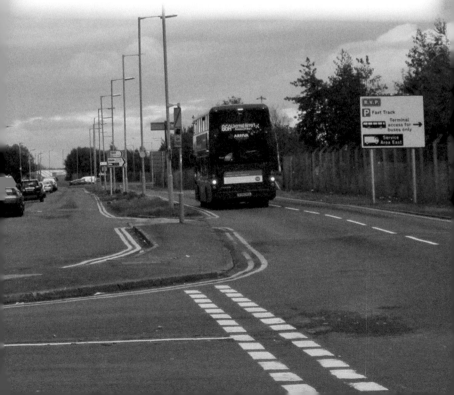

38. HALE ROAD TOWARDS EASTERN AVENUE

Crosville buses had been going down Hale Road for many years on their way towards Widnes and Warrington, but it was some time before Liverpool Corporation buses ventured down that road. 'Corpy' buses turned off at Eastern Avenue and made their way to the new bus terminus at the far end of Eastern Avenue.

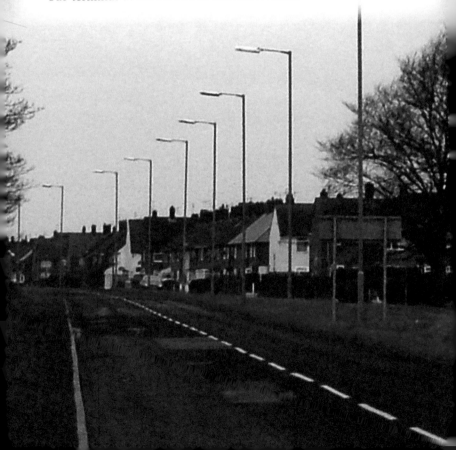

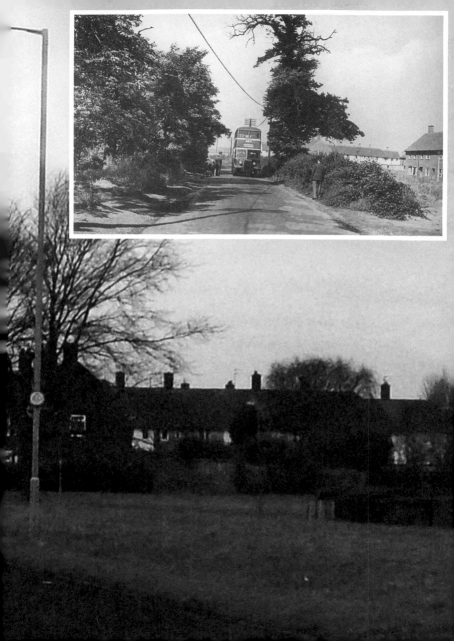

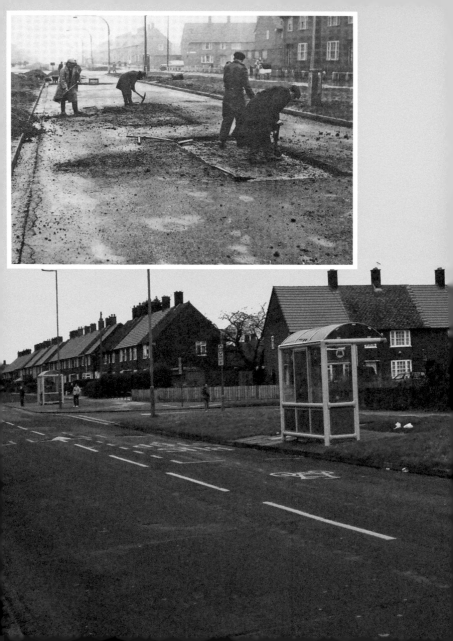

39. EASTERN AVENUE

Eastern Avenue, towards the far end of Speke and looking in the direction of Hale village, was one of the last major roads to be built on the new estate. However, shortly after the road had been opened, a major fault in the basic construction was discovered and significant remedial work carried out in February 1954.

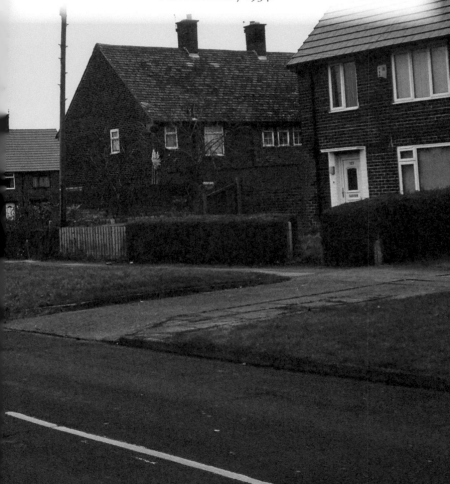

40. THE ROAD FROM SPEKE TO HALE

Walking along the road from Speke to Hale is to be transported from an urban development to a sleepy rural village of yesteryear.

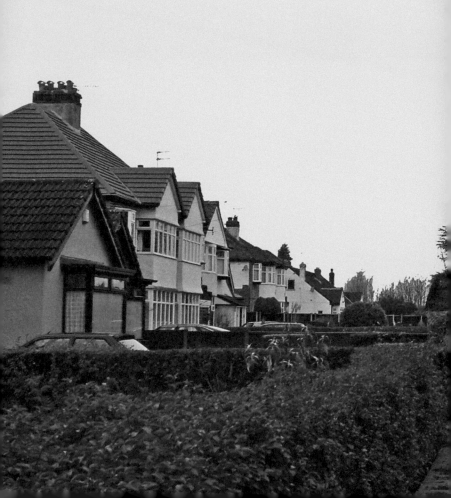

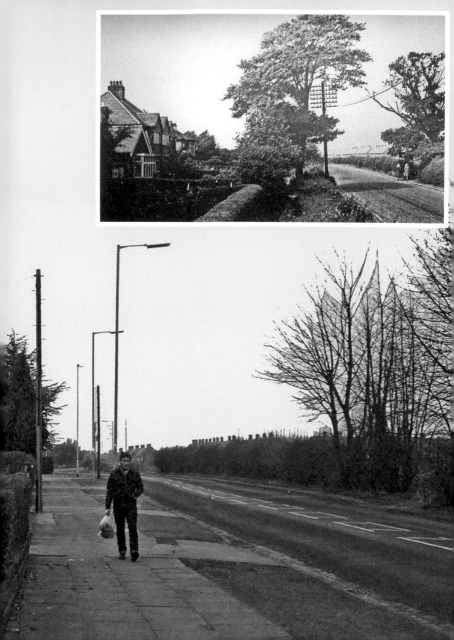

41. HALE WAR MEMORIAL

Travelling through the village of Hale towards Speke, it is necessary to negotiate the war memorial triangle. Hale Hall was situated in the grounds behind the house that can be seen in the photograph. The hall is no longer there, but Hale Park provides a much-used leisure facility for residents of the village.

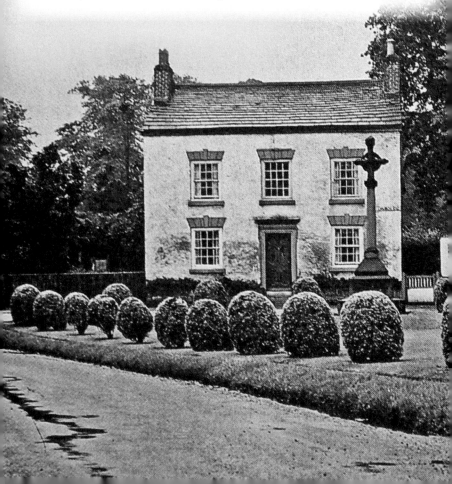

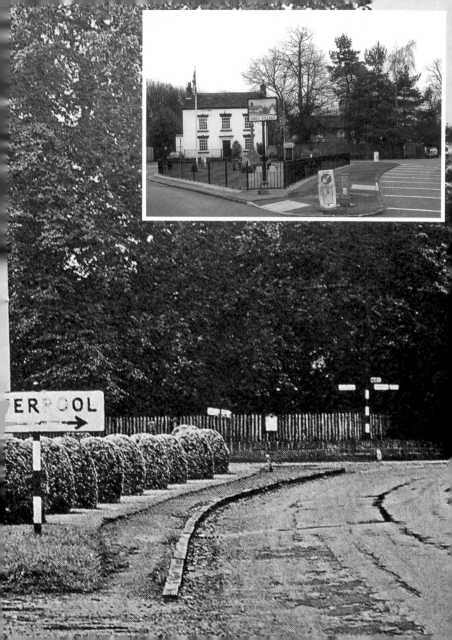

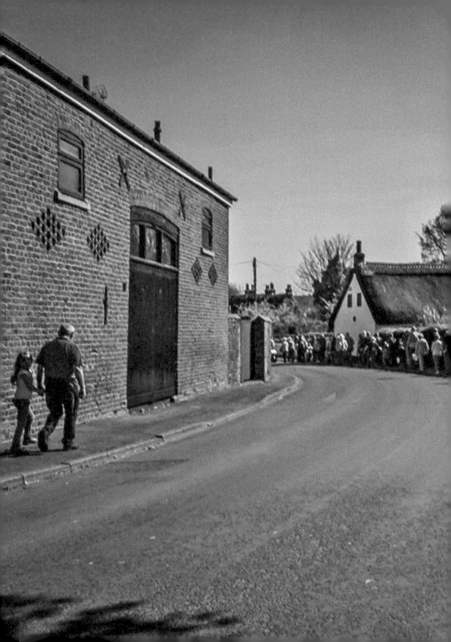

42. CHURCH END, HALE

Walking along Church End, which leads to St Mary's Church, Hale Head Lighthouse and also takes walkers past the cottage where the Childe of Hale once lived, is still a very popular route, especially on weekends and bank holidays. The Childe of Hale is reputed to have been of a gentle and caring nature, irrespective of his immense size. Legend dictates that, in order to accommodate his height, some of the roof beams in his cottage had to be removed. Legend also states that, at night, end windows in the cottage were left open so that his feet could stick out, thus helping him to get a good night's rest!

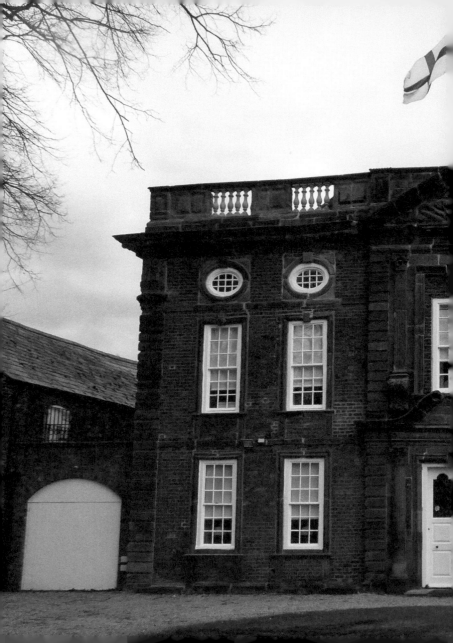

43. THE MANOR HOUSE, HALE

The Fleetwood-Hesketh family moved to Hale village in 1947, but Hale Hall, where they were to live, was considered to be almost beyond repair. They took up residence in the old Parsonage House, which later became known as the Manor House. Originally, the manor house was much smaller than what it is today. Sometime in the eighteenth century, Revd William Langford extended the property and added his coat of arms and monogram over the front entrance.

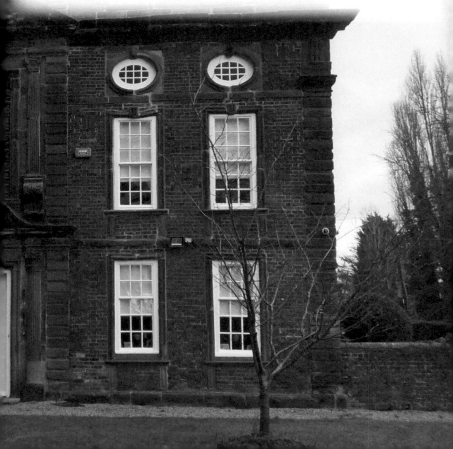

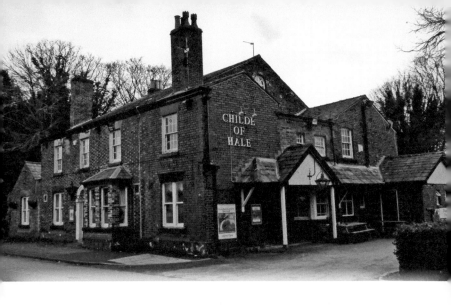

44. THE CHILDE OF HALE

John Middleton, the Childe of Hale, was born in 1578 and died on 23 August 1623. His grave is located on the south side of the church, surrounded by railings. On the grave is the inscription, 'Her lyeth the bodie of John Middleton the Childe nine feet three. Borne 1578 Dyede 1623.' King James I had heard about the Hale village giant who was the servant and bodyguard of Sir Gilbert Ireland. The king invited both men to attend court. A costume was specially made for John and when he was presented he created a sensation.

The king's champion challenged Middleton to a wrestling match and courtiers placed bets on the champion, but Middleton defeated him, dislocating his thumb. The king was in a difficult position and, not wanting to offend his courtiers, he sent Middleton home with a payment of £20 – a considerable sum in those days.

Travelling north, Ireland and Middleton called at Brasenose College, Oxford, where Sir Gilbert had graduated in 1578. When

the College Boat Club was established in 1815, the story of the Childe of Hale was an inspiration to the oarsmen and he became the mascot of the club. Unfortunately, during Middleton's journey home, he was robbed of his winnings. A contemporary source notes, 'he was coming down into the country, his comrades rob'd him of what he had, so that he was oblig'd to follow the plow to his dying day'.

Few contemporary likenesses of John Middleton exist, but in recent times, two notable sculptures have been created in the village. The first, known as the *History Tree*, was carved in 1996 by sculptors Phil Bews and Geoff Wilson from the trunk of a dead beech tree. When this structure eventually had to be removed, due to the ravages of nature, a replacement life-size bronze was created by Diane Gorvin and unveiled by the Mayor of Halton, Cllr Tom McInerney, on 11 April 2013.

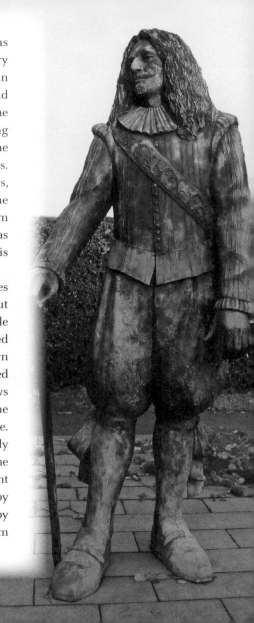

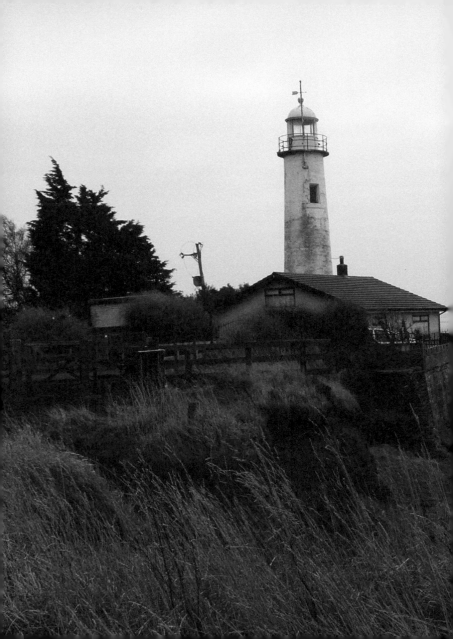

45. HALE HEAD LIGHTHOUSE

Hale Lighthouse stands at Hale Head, which is the widest part of the River Mersey, at almost 3 miles across. The lighthouse was built in 1906, replacing an earlier one that had been built on the same site in 1838. Small as it is, the lamp's beam could be seen up to 40 miles away – that is until it was decommissioned in 1958. Because of its width, the river is also very shallow at this point, which causes some treacherous currents and, before the Transporter Bridge was built at Widnes, this was the main crossing point to Weston in Cheshire. The Hale Ford crossing, as it was known, was used until well into the nineteenth century.

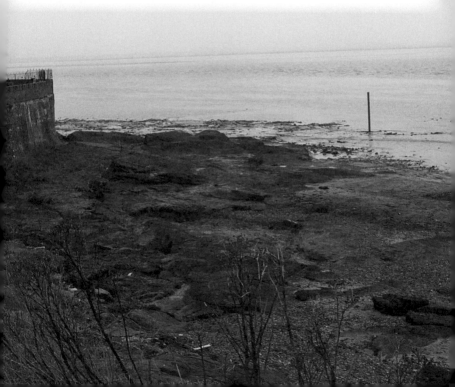

ABOUT THE AUTHOR

David Paul was born and brought up in Liverpool. Before entering the teaching profession, David served as an apprentice marine engineer with the Pacific Steam Navigation Company.

Since retiring, David has written a number of books on different aspects of the history of Derbyshire, Cheshire, Lancashire, Yorkshire, Shropshire and Liverpool.

Also by David Paul

Eyam: Plague Village
Historic Streets of Liverpool
Illustrated Tales of Cheshire
Illustrated Tales of Yorkshire
Illustrated Tales of Derbyshire
Illustrated Tales of Shropshire
Illustrated Tales of Lancashire
Speke to Me
Woolton History Tour
Around Speke Through Time
Woolton Through Time
Anfield Voices